The Art & Activism of Marion Perkins

The Art & Activism of Marion Perkins
"to see reality in a new light"

Edited by
Julia Perkins, Michael Flug, and David Lusenhof

TWP
THIRD WORLD PRESS

Progressive Black Publishing Since 1967

In partnership with the Vivian G. Harsh Society, Inc.

This catalogue commemorates the exhibition "*to see reality in a new light:' The Art & Activism of Marion Perkins*," held at the Vivian G. Harsh Research Collection of Afro-American History and Literature at the Carter G. Woodson Regional Library located at 9525 S. Halsted Street, Chicago, Illinois, 60628. Exhibit dates, January 31-December 31, 2009.

Co-Published by Third World Press, Chicago, Illinois and the Vivian G. Harsh Society, Chicago, Illinois.

Third World Press. Progressive Black Publishing Since 1967. Third World Press provides quality literature that primarily focuses on issues, themes, and critique related to an African American public. The mission of Third World Press is to make this literature accessible to as many individuals as possible, including our targeted market of primarily African American readers.

The Vivian G. Harsh Society seeks to ensure the preservation, growth, and development of the Vivian G. Harsh Research Collection by raising public consciousness and funds in support of the Collection. They seek to make this invaluable resource accessible to local, regional and national audiences.

Catalogue design: Jen Thomas, Veronica Press, Chicago, Illinois
Text set in Univers Light, Scala Sans Bold, and Scala Sans Italic
Photography: David Lusenhop, Chicago, Illinois (unless otherwise noted)
Copy editor: Lisa Meyerowitz, Evanston, Illinois

Permission to reproduce artworks in this catalogue has been provided by their owners or custodians.

ISBN: 978-0-88378-346-7

Contents

Of Marion Perkins . . .

Warmth, humor, joviality, modesty, humbleness.
Marion was such a common, uncommon man.
Imbued with tenderness, deep sincerity, gentle.
Fiercely loyal with friends. Adamant against foe.
Largely self taught. Ceaselessly seeking knowledge.
Minutely interested in people, all of them
Even the least and lowliest. Dedicated devoutly
To the class from which he sprang. And confident
In belief of its ultimate victory. Proud
Of heritage, proud. Held his head high always
Looked quite like a Masai warrior, passed on
Strength and beauty from his father's fathers, fathers.
Savored life as he lived it. Each moment precious.
Gave what he learned from over other's shoulders,
Encouraging, inspiring the coming on artists.
Manipulated clay. Carved wood. Hewed stone.
Incised in history and hearts also, his name.

Margaret Burroughs
© 1962

Introduction

In the 1930s, as the famed Harlem Renaissance of Black cultural achievement was winding down, a new surge of African American creativity, activism and scholarship began to flower in the South Side Chicago district then called Bronzeville. For two decades, the multidimensional movement found expression in literature, music, visual arts, social science and journalism. This flowering later came to be known as the Chicago Renaissance. The new art of the period clustered around the South Side Community Art Center, with work by Charles White, Gordon Parks, Charles Sebree, Eldzier Cortor, Margaret Burroughs—and a young sculptor named Marion Perkins.

For the past ten years, the Chicago Public Library's Vivian G. Harsh Research Collection of Afro-American History and Literature has sought to promote the preservation, study, and dissemination of the achievements of the Chicago Renaissance. We were thrilled when the children and grandchildren of Marion Perkins visited the Harsh Collection and proposed an exhibit on the life, art, and legacy of this compelling, but little-studied sculptor.

His career was nothing like what most of us imagine as the life of an artist. "Many a warm summer evening finds Marion Perkins relaxing in the back yard of his home," the *Chicago Tribune* reported in 1947. "The Perkins relaxation method, however, is neither puttering in a garden nor plunking himself down in a hammock to read the paper. Instead he hauls out a heavy block of limestone, often obtained from some vacant lot or razed building . . . Standing on the overworked feet that supported him all day in the post office, he sets out to sculpture another piece . . ." For us, Perkins's remarkable fusion of art, daily life, and his commitment to struggle best expressed the unique character of the Chicago Renaissance.

Through the generosity of the Art Institute of Chicago, the DuSable Museum of African American History, and nearly a dozen private collectors and friends, we were able to mount an exhibit that documented the full range of Marion Perkins's art—and to place his art in the context of social protests, artistic friendships, and family life. We were delighted to exhibit his powerful 1948 work, *Ethiopia Awakening*, and to place it next to his 1935 poem written as Mussolini's army invaded Ethiopia. We positioned a photograph of Perkins's wife, Eva, looking toward his marble sculpture, *Portrait of Eva*. We underlined the multidisciplinary character of the Chicago Renaissance by exhibiting correspondence between Perkins and playwright Theodore Ward, and by showing a group photograph of Perkins with artist Margaret Burroughs, poet Gwendolyn Brooks, writers Fern Gayden and Robert Lucas, and journalist Vernon Jarrett.

It has been a great joy to see the intense public response to the exhibit from both older viewers who remembered Marion Perkins and from teenagers who had never heard of him but were fascinated with his range of sculpture subjects and his materials. Many also commented on the text of his keynote address to the 1959 National Conference of Negro Artists.

Belatedly, the public response impelled us to create this catalogue of the exhibition. In the pages that follow, you will see many of the works that excited the viewers.

The catalogue committee, co-chaired by David Lusenhop and Julia Perkins, devoted countless hours to the project, and deserves our heartfelt thanks. David was the photographer, documenting all the sculptures in the exhibit. Julia was the writer, seamlessly piecing together the interpretive text panels from the exhibit with her own expression.

Michael Flug, Senior Archivist

Vivian G. Harsh Research Collection of Afro-American History and Literature, Chicago Public Library

The Art & Activism of Marion Perkins

Art to me is a means of communication with my fellow men, seeking to help them to see reality in a new light, arousing their sensibilities to respond to beauty and hope in this world. It is for this reason that I believe the best art must always be anchored to reality. That it must somehow enable the spectator to see the material truths around him in a new light that out of the material emanates the spiritual.

—Marion Perkins

Marion Perkins was a husband, father, laborer, activist, and an artist. Through his art, Marion Perkins imparted social and political commentary on the injustices and challenges faced by African Americans during the 1930s, 40s, and 50s.

This catalogue is a tribute to the man and the exhibition "*'to see reality in a new light': the Art & Activism of Marion Perkins*," which marked the first comprehensive survey of his legacy and contribution to the landscape of American art.

Beginnings

There are many gaps in our knowledge and much conjecture about the life of Marion Perkins, especially during his early years. Perkins was born in Marche, Arkansas—near Little Rock—in 1908. In the late 1800s and early 1900s, during the years of Jim Crow, it was not unusual for children to be born in the South without official certificates of birth. Perkins's precise birth date and even the names of his parents remain elusive.

In 1916, Perkins arrived in Chicago as an eight-year-old child. The Great Migration was at its height, as more than one million Blacks journeyed to cities, including Chicago, to pursue a better way of life. We do not know what triggered his relocation to Chicago. According to family oral history, Doris Padrone, possibly a friend of one of Perkins's Arkansas relatives, became his caregiver. Marion Perkins attended Wendell Phillips High School, the first Chicago high school with a Black majority student body. He did not complete his senior year.

Shortly thereafter he married Eva Gillon, who came to Chicago from Louisiana. In 1929, Eva gave birth to the first of three sons just as the Great Depression was erupting. By 1932, staggering unemployment, food lines, and social protests were facts of Chicago life; more than 50 percent of African Americans were jobless. Despite these hardships, Perkins tirelessly supported his family through a series of menial jobs, including selling newspapers, washing dishes, and loading cargo for trucks.

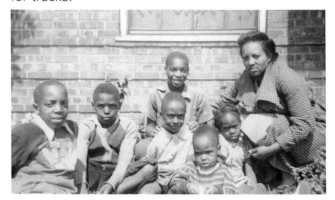

Eva Gillon Perkins with her sons and their cousins, c. 1940

The Chicago Renaissance

The Harlem Renaissance (1918–1930) is often highlighted as the most important period that contributed to the emergence of Black artists. However, the renaissance that took place in Chicago (1932–1950) also played a significant role in this cultural flowering. Arna Bontemps, who participated in both these movements, stated: "Chicago was the center of the second phase of Negro literary awakening."[1]

The movement we now call the Chicago Renaissance emerged out of the hardships and social protests that swept Black Chicago in the 1930s. In the last half of that decade, Marion Perkins began his career as an artist. While these

1. Arna Bontemps, "Famous WPA Authors, *Negro Digest 8* (June 1950): 43-47.

beginnings are known only in outline, the Chicago Renaissance was a catalyst that ignited his artistic expressions in sculpting and writing, and fueled his passion for knowledge and social and political equality.

The Chicago Renaissance fostered a cultural aesthetic in the visual and literary arts unique to Black America. There was no barrier dividing visual artists from writers in the Chicago Renaissance, and both were constantly presenting and discussing their work with an activist community in Bronzeville. Novelist Willard Motley pointed to Charles White, Elizabeth Catlett, Eldzier Cortor, Bernard Goss, and Charles Davis as being among the vanguard of new black artists in late 1930s Chicago. In *The Chicago Black Renaissance and Women's Activism*, Anne Knupfer acknowledged the scope of this movement when she stated that "Chicago Black writers and artists created a cultural and political front during the Chicago Black Renaissance."[2] Many of the artists were prominent in social justice protests during the Depression and World War II.

While both the Harlem Renaissance and the Chicago Renaissance produced outstanding Black artists, there were significant differences between them. The Harlem Renaissance was heavily funded by white patrons of the arts, while the programs that helped Chicago Black artists were primarily funded by the Works Progress Administration's Federal Art Project (WPA/FAP). This program supported Black artists in Chicago, providing many—and some for the first time—with resources to work on their art full-time. To qualify for the WPA/FAP, all artists had to meet professional standards and the requirements of the Illinois WPA Relief Board. Perkins experienced no difficulty in satisfying these qualifications.

The Style and Technique

Although Marion Perkins is considered primarily as a stone carver, during his career he explored a variety of techniques and materials. Early in his

2. Anne Meis Knupfer, *The Chicago Black Renaissance and Women's Activism* (Urbana, IL: University of Illinois Press), 2006.

life he whittled and carved in soft materials, such as soap and wood. His purchase of a newsstand at 37th and Indiana in the late 1930s gave him the space and independence to establish a kind of outdoor studio where he could carve large-scale heads during less hectic periods in the day. During the Depression, Perkins was able to obtain very fine raw materials, such as marble, in the empty lots and abandoned ruins of the grand South Side homes once inhabited by Chicago's

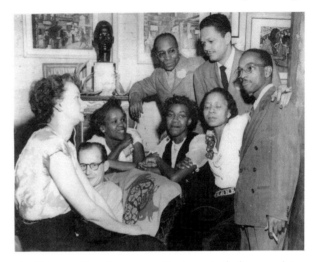

A Chicago Renaissance gathering, including sculptor Marion Perkins, journalist Vernon Jarrett, writer Robert Lucas, art center director Margaret Brundage, writer Fern Gayden, poet Gwendolyn Brooks, and artist Margaret Burroughs, 1948.

wealthiest families. Perkins jokingly referred to these expeditions to gather materials as "midnight requisitioning."

Perkins probably favored carving in stone for its beauty as well as its durability and hardness. Carving in stone takes both great strength as well as patience —qualities Perkins must have had in deep reserve. Creating a sculpture in stone might take months of work, requiring the use of a range of specialized tools to obtain the variety of surface textures and effects. Perkins also clearly enjoyed exploiting the natural patterns and variations in grain and crystal. Carving directly in stone may have appealed to Perkins for another reason as well: its attraction by modernist sculptors such as Gauguin, Brancusi, and Picasso,

who were interested in African, Oceanic, and other nonwestern traditions of direct carving. Alain Locke, the Howard University professor of philosophy and author of the *New Negro* anthology (1925), also recommended that African American artists follow the example of modernist sculptors and examine the roots of modernism in the arts of Africa.

In addition to direct carving—that is, creating form by reductive means—Perkins also used the additive technique of modeling in clay in order to create sculptural works that could be cast in plaster, bronze, or cast stone. Many of his Skywatchers series, for example, are cast in plaster. Perkins took courses in ceramics at Hull House in the early 1940s as well. Finally, Perkins experimented with newspaper bailing wire to create heads that look totally modern in material and technique but are in shape reminiscent of Central African Songye masks.

The Artistry

The work of Marion Perkins received little attention until he exhibited two stone pieces —of a boy and a girl—at the 1940 American Negro Exposition's art exhibit. At about the same time he received a commission from a hotel in South Haven, Michigan, when he was also selected for inclusion in "Art of the American Negro." Part of the American Negro Exposition at the Coliseum at 15th and Wabash, the exhibition presented works by such celebrated artists as Henry Ossawa Tanner, Archibald Motley, Augusta Savage, and contemporaries of Perkins such as Jacob Lawrence, Charles White, Elizabeth Catlett, and Hale Woodruff.

This historic show was at that time the most comprehensive national exposition of African American artists to date. It also was a major milestone in the evolution of Chicago's Black Renaissance, and proved to be Perkins's springboard to wider recognition. Within months of the exposition, the South Side Community Arts Center was born. Marion Perkins played a major role in the early years of this outstanding cultural institution, and remained active there until his death in 1961.

Perkins's most impressive early triumph was the inclusion of his first great sculpture, *John Henry*, in the prestigious "Annual Exhibition of American Art" at the Art Institute of Chicago in 1942. A study in concentrated, coiled energy, his *John Henry* is emblematic of the untapped potential of the black worker during World War II.

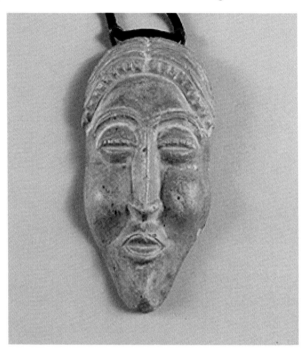

Pendant sculpted by Marion Perkins, 1950s.

The hammer-wielding folk hero was also a symbolic self-portrait of Perkins as sculptor/worker. As the 1940s progressed, Perkins gained confidence, control, and mastery and continued to show at the Art Institute annual exhibitions. The hallmark of his work was the extraordinary physicality that conveyed an underlying spiritual strength of his black subjects.

Ethiopia Awakening, Perkins's quiet but powerful personification of the most ancient and independent state in Africa, won second prize for sculpture at the Art Institute's 1948 "Chicago and Vicinity" exhibition. Carved from a classical, fluted, green marble column he may have found in the ruins of an abandoned Bronzeville mansion, *Ethiopia Awakening* was not Perkins's first tribute to Ethiopia. During the 1930s, before Perkins began his career as a sculptor, the streets and

churches of Chicago were often filled with mass protests in support of the Ethiopian cause. In response to the second attack on Ethiopia by the Italian army in 1935, Perkins published a poem in the *Chicago Defender* titled, "Adowa May Be Avenged," referencing the 1896 battle in which the Ethiopian army first defeated the Italians.

Perkins's reputation as an artist grew exponentially during the 1940s, despite the fact that he was still forced to work full-time in blue-collar jobs. In 1948, Perkins was awarded a grant from the Julius Rosenwald Fund, a Chicago-based philanthropic organization that supported African American artists, writers, and teachers. The fellowship came at an opportune moment, since Perkins had just lost his job as a postal worker for refusing to sign the loyalty oath required of all federal employees as part of the cold war policies of the Truman administration. The Rosenwald grant proved to be his only such opportunity to work as a sculptor free from the demands of other full-time jobs.

In 1950, Marion Perkins was hard at work, carving in marble a new sculpture which he titled *Man of Sorrows*. "[It] is one of my favorites," Perkins said. "To me, it shows a Negro's concept of Christ. I carved Him in our image and the face reflects the past suffering of my people in a strong and forceful way."[3] exhibited at the Art Institute of Chicago's 1951 Chicago and vicinity show, it was immediately acclaimed. "Not only did this Christ figure win a prize," art historian Daniel Schulman wrote, "but the museum purchased it from the show, which brought Perkins an unprecedented measure of recognition."[4]

The October 1951 issue of *Ebony* magazine published a long article on Perkins and his work written by Herbert Nipson, with an eye-catching splash of photos by Mike Shea. *Life* magazine sent photographer Ralph Crane to accompany Perkins for several days, documenting him sculpting in his studio and on his job as a freight handler. The *Life* article was never published but the *Ebony* feature, combined with many glowing comments on *Man of Sorrows* by art critics, elevated Perkins near the top ranks of African American artists.

The Art of Activism

Unfortunately, this rise to prominence coincided with the height of the cold war. Perkins's radical political views, which had already forced him out of employment at the post office in 1948, now made it difficult for him to gain funding so that he could devote full-time to his art. He turned to work on a new series of sculptures, *Skywatchers*, which he had first envisioned after the bombing of Hiroshima. Perkins sought to create an ensemble work, "with each individual figure portraying some aspect of Hiroshima."[5] Although many of the pieces were exhibited in 1954, the work as a whole remained unfinished.

In this period Marion Perkins accepted an offer to teach art in Mississippi, at Jackson State Teachers College (now Jackson State University). He may have been invited there by renowned author and professor Margaret Walker, whom Perkins had known in the South Side Writers Group of the 1930s and 1940s. On his return to Chicago he continued his teaching role, counseling young artists at the South Side Community Art Center.

Toward the end of the decade, new movements for African liberation and new movements for civil rights in the United States began to exchange ideas in a two-way road to freedom. These ideas coalesced in the 1959 formation of the National Conference of Negro Artists. It was to this fledgling movement that Perkins devoted much of his energies in the last years of his life.

Marion Perkins was a product of the mass migration of African Americans from the rural south to the urban north and a by-product of the new creativity and ideals produced during the New Deal era. The broken promises of that era

3. Marion Perkins, quoted in "Marion Perkins," *Ebony* 6:12 (October 1951), p. 109.

4. Daniel Schulman, "Marion Perkins: A Chicago Sculptor Rediscovered," *Museum Studies* (Art Institute of Chicago) 24:2, 1999, p. 236.

5. Marion Perkins, "Hiroshima in Sculpture," *Masses and Mainstream*, August 1952, p. 42.

both energized his work and frustrated his psyche. Perkins once said:

"To be an artist and a Negro presupposes problems whether one likes it or not. In fact, just to be a Negro in America creates a problem . . . "

These words are part of the keynote address given by Marion Perkins at the first National Conference of Negro Artists held in Atlanta in March 1959. This conference arose out of a remarkable series of new international events organized by peoples of color.

In April 1955, the world witnessed the first international conference of what came to be called the Third World in Bandung, Indonesia. This conference, led by Africans and Asians, was,

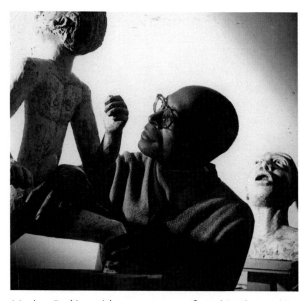

Marion Perkins with two scuptures from his Skywatchers series, c. 1955

in turn, the impetus for the First International Congress of Negro Writers and Artists in Paris, France, in 1956. Richard Wright, author of *Native Son*, was on the planning committee for the first conference; Margaret Burroughs attended it. The following year, American delegates to that conference established the American Society of African Culture (AMSAC). By 1959, AMSAC organized the first Conference of Negro Writers in New York City "to exchange and evaluate their experience on the problems of being writers in addition to being Negroes."[6]

While Perkins could not travel to any of these meetings, writers and artists from his circle did go, and reported their findings back to Chicago. Perkins felt that the aims of Black writers and artists were similar in nature and hoped to establish a more permanent link between them to collectively aid the liberation struggle. A few weeks after the Negro Writers conference in New York, the National Conference of Negro Artists was launched in Atlanta. It was here that Marion Perkins eloquently articulated "The Problems of the Negro Artist" (reprinted here, starting on p. 8).

Perkins saw the ambivalence of the Black artist in stark terms: the inaccessibility of vehicles for educating artists, the reliance on white patronage that inherently stifled creativity and freedom, and the limitations of the artist's audience, especially in a society where the Black artist was seen as inferior.

In 1959, America was on the brink of the Civil Rights Movement, while the call for African liberation was heard internationally. The parallel movements of Africans and Black Americans seeking liberation forged unifying ties among peoples of African descent all over the world. Perkins spoke to this unification in his address at Atlanta. He urged the renewal of ancestral ties: "We must begin to see that the African liberation struggle aids our struggle."

While he died four years prior to the emergence of the Black Arts Movement (1965–1975), Marion Perkins's legacy did have an influence on some of the Black artists who helped to shape it. Even though his political views may have appeared to differ from the Black Nationalist doctrine that gave philosophical grounding to the movement, they did not prevent young Black artists from seeing him as a role model. Douglas Williams, former director of the South Side Art Center, first met Perkins when Williams was a fledgling sculptor. Douglas has stated that Perkins was his "hero in the art world

6. Marion Perkins, "The Problems of the Negro Artist," speech to the National Conference of Negro Artists, 1959. See text of speech beginning on p. 12 of this book.

and made an enormous impression on me."

Similarly, Calvin Jones, one of the Black Arts Movement's talented artist/muralists commented

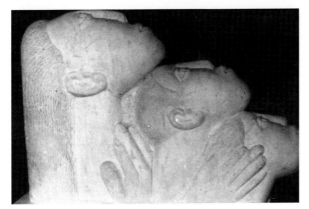

One of the Skywatcher series of sculptures, 1950s

that he "admired Marion Perkins's work ethic." His admiration led him to feature Perkins as the primary image in an acclaimed mural entitled "Builders of the Cultural Present," which he painted on 71st Street and also prominently pictured Gwendolyn Brooks. Other Black Arts Movement artists who recognized Marion Perkins's work as influential to their own art included Ramon Price, curator of the DuSable Museum of African American History, and AfriCOBRA artists Murry DePillars and Jeff Donaldson. AfriCOBRA became one of the most notable and African-centered groups that embraced the Black Arts Movement.

Had Marion Perkins lived during the Black Arts Movement more than likely he would have played an active role in it. His strong interest in traditional African art, and his belief that art should be a reflection of a people's struggle, were consistent with the philosophy of the Black Arts Movement. And his strong support of the common man was consistent with the 1960s and 1970s Black artists who ventured out into their respective communities to bring their art to the people. Art for art's sake was no longer valid during the Black Arts Movement; to be relevant art had to relate to struggle.

In retrospect, Marion Perkins's address at the 1959 National Conference of Negro Artists can be seen as a visionary statement that encapsulates the spirit of the Black Arts Movement. Since history represents a continuum of events that chronicles the past, it's important to acknowledge the contributions made by each generation. Therefore, to appreciate the works of the Black artists who created the Black Arts Movement, we must acknowledge the works of the artists who came before them. Marion Perkins was so acknowledged as a giant among these pioneering artists.

Not for a single year in his life was Perkins able to devote full time to his art as a sculptor. Yet he became one of the most important visual artists in the Chicago Renaissance. His career was short; it did not begin until he was over 30. Although he died in 1961 at the age of 53, he combined, as few others have, a unique artistic vantage point with a fierce dedication to social justice. As Schulman has observed, "stylistically conservative, Perkins's work nonetheless is remarkably beautiful, emotionally authentic, and politically impassioned… A reconsideration of his valuable, but largely unknown, legacy is long overdue."

Julia Perkins
In collaboration with the Marion Perkins exhibition committee

The Problems of the Negro Artist

Marion Perkins, keynote address to the National Conference of Negro Artists, Atlanta, Georgia, 1959.

All of you know the title for the subject of my talk tonight—Problems of the Negro Artist. Unfortunately—this word "problem" arouses unpleasant reactions among many of us. It is a word that is kind of worn and battered and one wishes at times that it could be completely abolished and something more inspiring substituted. But this in itself becomes a problem. But to heap injury on to insult—it's the last two words in the title which affect some like a red rag waved in the face of a bull—and that's the expression—Negro Artist. At times I am inclined to sympathize with them because of the manner in which it has been used by our avowed enemies and a few of our patronizing friends. Nevertheless, to be an artist and a Negro presupposes problems whether one likes it or not. In fact just to be a Negro in America creates a problem, and from what one can glean from the press, quite a serious one. Well, we are assembled here, the first national gathering of Negro artists to my knowledge to take place in this country, And I am sure we all are looking forward to the hope that at the conclusion of this conference, the problems, through our collective exchange of experiences and ideas, will become more sharply defined and put in proper focus so that we can take constructive measures to overcome many of them.

It is very fitting that this historic gathering should take place here in Atlanta University, prior to the opening of its 18th anniversary All-Negro Art Show, where in its repository there exists, without doubt, one of the most notable collections of art created by Negro artists within this country. There may be some who have reservations as to the wisdom of such a show, and think in terms of the opposition that existed at its very beginning. But I wonder if they can deny that within the eighteen years of its existence, it still offers the greatest opportunity of any other Art Show in the country to be accepted and exhibited. When I speak in these words, I feel that I can speak with some authority having achieved some modest recognition as an artist nationally. But we have not met here to belabor this question, but to explore ways and means of opening up more opportunities to our aspiring artists.

We are not alone in taking some collective efforts to examine our position in today's troubled world. A few weeks ago another historic conference of Negro writers, sponsored by the American Society of African Culture, met in New York to exchange and evaluate their experiences on the problems of being writers in addition to being Negroes. There is an added significance—that this conference of Negro writers which met there obtained their cue from the "International Conference of Negro Writers and Artists" held in Paris in 1956 under the leadership of African intellectuals. This contagious spiritual renaissance of Black, Yellow, and Brown intellectual and cultural forces throughout the world to meet to discuss and examine their common problems, evidently points to some great inherent need.

Today the subject races and nations of Africa and Asia are beginning to awaken to the fact that their own culture, a knowledge of its origin, and its contribution to human development is one of the essential ingredients to give a race or nation a cohesiveness and a definite feeling of self respect. Western culture, in spite of its tremendous material achievements, stands at the crossroads where the questions of human relations are concerned, and finds it difficult to translate its moral concept of the brotherhood of man into a living reality. So we find those intellectuals within these groups, dominated by European and American civilization, beginning to free themselves from the hypnotic spell of its self-acclaimed superiority.

I know everyone here would like to know some of the results of the New York conference,

I understand that Mrs. Margaret Burroughs contacted the chairman of the conference and invited him to send an observer to our proceedings. If that representative is here, I am sure we would welcome a short report on the results of the conference. In the meantime I would like briefly to report some of the results as reported by the press. Speaking of the press and news worthiness of this unique event, it is amusing to note that the American Press, with few exceptions, failed to even give it a byline; and the Negro Press, also American, devoted a few begrudging inches to this, in its estimation, not so momentous event.

I have no desire to quarrel with the brethrens who are dispensers of our daily or weekly news. They know their public and it is common knowledge that intellectual and cultural gatherings do not rate headlines or sub-headlines in American life. Anyway, the final aims of this conference, to me, appear very gratifying from what I could see— plans for a quarterly publication, for the Negro Theatre, an award for the best Negro writer, grants to send Negro writers to Africa and the final plan to give the conference permanency. These aims I subscribe to wholeheartedly. It is my hope that out of this conference we can establish a closer liaison with them. A united cultural movement of all the arts would be a healthy thing. Let us not forget that we are all in the same boat with all the Negro people piloting through the storm toward the same cherished goal—full democratic rights and first class American citizenship.

I would like now to get down to the nub of the question as to why we are assembled here this evening. All of us are interested in the shop-talk, the specific questions confronting every creative artist within his particular field. Much of what I have to say comes out of personal experiences as one who has made an attempt to do some serious creative work, along with the experience and ideas of others in the field of plastic arts, and along with numerous books and periodicals which I try to keep up with in order to stay abreast of the development of art in American life. The fact has to be faced that art, like any other commodity in American life, is subject to the instability of the craze, the trend, the change, a pathological kind of attitude into which the American people have become so conditioned to until nearly everybody is looking forward to tomorrow's model before yesterday's has been tested out thoroughly and probably could serve just as well. If some of the old masters, developed in the Western world's traditional concepts of art, should return today and attend an exhibition of art such as the recent Carnegie show, I am certain they would become completely bewildered by what they are seeing. Yet, it becomes necessary to keep up with viewing what others are doing, for always there is something one may learn which may help one's own development.

There are three major problems that I want to briefly explore: namely becoming an artist, which consists of that inner urge to seriously express one's self in one of the varied cultural media used in communicating with our fellow men. In order to communicate successfully in one's chosen media, one must achieve a reasonable knowledge and mastery of one's craft. Second, content—the very essence of any art in which one can become engaged in such an endless controversy and speculation, until one becomes so bogged down until nothing is accomplished. Then third—how to reach the spectator, whether it be one or many. (Personally, I say, the more the merrier, in spite of those snobbish creatures who pride themselves that their creations can be understood by the selected few, or claim that they are only indulging in the creative process as an outlet for their frustrations.) The three problems enumerated are ones which every creative person has to face regardless of race or nationality. But where the Negro is concerned, they take on a special connotation, and involve special difficulties as in the matter of preparation for one's career—obtaining adequate training—so one can successfully accomplish one's objective. This is the number one problem in the mind of every intelligent Negro. Those who seek to throw up the smoke screen that the Negro is seeking integration in the school merely for the sake of integration falsifies the real issue. What Negroes seek is equal education and

opportunities and to obtain the best regardless of which side of the track the best is located. The Negro artist is especially handicapped in certain sections of the country where there is a dearth of art schools or art departments with adequate facilities and competent instructors.

On the question of content, its treatment, its purpose—what to paint, what to sculpt, these are problems which plague every artist. But the social milieu in which the Negro artist is condemned to reside plays a dominant role in conditioning his outlook and reactions. Carl Milton Hughes in his book *The Negro Novelist* sums this situation up accurately when he states,

> But there are numerous factors in the environment which operate against the Negro, and as such must be carefully documented and projected in narrative form for the sake of advocating change. Negro novelists stress the role of the underprivileged and the dispossessed Negro inhabitant of America. There is an indictment of society in the novel of protest because the society in which the Negro lives permits vice and corruption to undermine basic personality growth. Environmental factors pave the way for the demoralization of the character of many Negroes. These problems arise from wrongs in American society which the Negro novelist considers too urgent to by-pass.

The Negro artist finds the same factors operative in dictating his attitude toward his material. The vogue of abstract-expressionism and similar abstract theories which are being loudly acclaimed by the guardians of the art world in American today—has small attraction to the Negro artists confronted with harsh human realities and impelled with the desire to uplift old masters, and to seek to demolish the stereotype which persist in being cherished in the minds of white America. If this is true, it will account for the unacceptance of works by Negro artists at many of the major shows. This fact holds true in so far as many white artists are concerned who persist in retaining the realistic image upon their canvas. The biased dictators of The Academy of Modern Art insist on using their narrow conception as to the worthiness of a picture or piece of sculpture. If it lacks ambiguity, a favorite word cherished in the vocabulary of the extreme moderns, or if it is not something novel with a shock value to hit the spectator between the eyes, they refuse to label it as art. There are some who may question my assertion. I ask, it if is not true, why is that not one of the national art magazines in America consider this unique collection here in Atlanta worthy of a critical article. Surely these gentlemen cannot be unaware of this collection and the yearly annual art show. It becomes increasingly clear that the Negro artist can look for few laurels from the lords of the modern academy. A few pass the test for one reason or another, probably at time only because of expediency. In the effort to sell American democracy to the world, how can the happy successful face of the darker brother be omitted as a commodity?

Friends and fellow artists, I think this situation highlights one undeniable fact. The time has come when we have to evaluate our own endeavors, when we must separate the men from the boys among ourselves, when we must turn to the spirit of Alain Locke and to the still living courage of DuBois and Paul Robeson. Let's honor those among us who give wings to our spirit, who create an art to sustain the bitter defeats and celebrate the hard won victories. It is true that the depressing, the ridiculous, and the ribald comic spirit exist among us. But the down to earth and sympathetic image of a Langston Hughes' Simple has far greater artistic validity than the so called representative samples of Negro life such as *Porgy and Bess*, which was the arbitrary choice of the white hierarchy for a trip abroad. Unquestionably, it was amusing and entertaining to the European brethren, but one wonders about the reaction of our African and Asian brothers. For the fifth time, the beloved play of a large section of white America, *Green Pastures*, with its wonderful odors of fish frys in heaven is nationally televised with fanfare and with acclaims. And let us not forget the greatest example of the debased

mentality of certain sections of American public with its tolerant support of an outmoded black face minstrel program on radio and television for nearly three decades such as *Amos 'N' Andy*. I often marvel why it has not been awarded the Pulitzer Prize. Unquestionably, our own indifference and lack of social alertness has contributed much to the continued existence of such caricatures of Negro life. And I would like to point out that our artists and sculptors can play a major role in replacing the stereotype with the true image of Negroes and Negro life. To my mind, a dedicated artist like Charlie White, portraying his people with love, with sympathy, with dignity, exemplifies the desire and creative efforts of most Negro artists.

So much for content. What about the audience? Who must the Negro artist paint for? I say if he creates with integrity, seeks to communicate with legible image, takes his wares to the outdoor show, he will find the people receiving his works with admiring eyes. For the people everywhere, whether white or black, view the artist as a miracle worker. Of course they will hesitate to ask the price, for they have been taught that works of art are usually beyond the ordinary man's means, which they usually are. But if you assure them that you will make an exception in their case, and since they appreciate it so much, you will be surprised at the result. In my estimation, the open outdoor art shows in the public squares and shopping centers in many sections of America is one of the healthiest developments in our national life today. Many people who would not dare to put a foot in the museums come out, and for the first time look at pictures and sculpture and see living artists in the bargain.

Of course, I do not mean that the artist should let up in his struggle to make some of the shows in his region and nationally if he can and seek to obtain the recognition that is his due. After all, we cannot afford to abdicate to the abstract academicians who rule the roost in the art world today. I say to every Negro artist—work diligently to master your craft, explore all the avenues for the direction in which you can express your talent more effectively. In case there has been some

mistaken impression that I am unalterably opposed to certain modern manifestations in the art world today, allow me to clear the record. I am opposed to the tyrannical dictation of those who seek to narrow the concept of the function of art; who seek to brand efforts at social and moral comment as irrelevant or propaganda; who decry realism as illustration; and in the name of freedom, uphold the anarchistic license that prevails today. Is it not enough that there are dangerous war-minded men with unimaginable instruments of destruction wrestling on the brink of chaos, without an art that is only adding to the confusion? Never before has mankind been faced with a greater need for expressions of clarity to arouse his sense of humility, which only those who command the language of the arts are able to give. There is no denying the fantastic miracles accomplished by science today, with its promise of unlimited blessings. But only the men with minds bathed in the light of the humanities will be able to help translate these into reality.

In regards to some of the specific tasks I feel that we must tackle at this conference, first, there is the Atlanta Art Show here in the heart of the South, where numbers of our white brethren are painfully engaged in a struggle to make a moral reassessment of a conditioned immoral attitude toward their darker brother. In my estimation the show must continue and we must help it grow. We must build collectively with the loving hands of the master craftsmen, until, like of the mighty Gothic cathedrals, the spires of our endeavor will tower to the heavens as a special testimony to our faith in the South and in America. There are some who feel that the show must be broadened to include white artists. Certainly this idea merits discussion. There is a second task that we are faced with, though some may be unaware of it. 1963 will be the century mark since the signing of the Proclamation of Emancipation. A while back in idealistic fervor a slogan was formulated: "Free by '63," to cap anticipated celebration of this coming important event. With enthusiasm I subscribe to such a celebration, though I feel somewhat dubious that the slogan can become

a complete reality. But I feel it devolves upon us, the Negro artists, the writers, the musicians, the actors, along with all the progressive forces in America, to begin now laying the foundation for such a celebration which will symbolize the ending of an era and the beginning of a new one. We must begin now to intensify our creative efforts in order at that time to have the books and plays written, the pictures painted, the sculptures made that will be worthy of this great occasion, in which we shall be the arbiters, to present to the world the American Negro's real cultural contribution. We should begin now to marshal our supporters; progressive labor, the liberals in deeds instead of words, the Christians who practice their religion instead of just preaching it, and the mass of our struggling people who toil daily to provide their children with an opportunity for a better life. Friends, before I conclude my talk, I would like to read you two quotations, one by a now deceased, eminent American Negro poet, Countee P. Cullen, and the other by a living African intellectual, Keita Fodeba, born in French Guinea and the organizer and director of the African Ballet Company and an acknowledged authority on the African Dance. Permit me to read to you from one of Mr. Cullen's memorable poems.*

What is Africa to me:
Copper sun or scarlet sea,
Jungle star or jungle track,
Strong bronzed men, or regal black
Women from whose loins I sprang
When the birds of Eden sang?
One three centuries removed
From the scenes his fathers loved,
Spicy grove, cinnamon tree,
What is Africa to me?

I feel sure that had Countee P. Cullen been fortunate enough to be alive today he would have greeted the mighty African liberation movement with fitting verse. But we cannot deny that at the time he wrote this beautiful poem, it reflected that attitude of most of our people who where enslaved and spirited thousands of miles from the land of their heritage, and their culture ridiculed and nearly erased from their consciousness. Now, for this remarkable insight into the dilemma of his American darker brother by Keitu Fodeba. I quote:

Our transplanted brothers have generally been placed in such political, moral and material conditions, that as a result of retiring within themselves, so often they have reinforced their psychic bonds with our continent. Owing to the dominating effect of conditions of environment upon the individual, it would seem difficult to speak of a culture of the Negro World. Yet, to the best of our knowledge, nowhere in the world during the long years of their tragic expatriation have the Black races enjoyed social and economic conditions which were sufficient to destroy utterly their original ties.

On the one hand, Africa being the land of origin of the Negroes, we can probably deduce that for a long time, and whenever they are, they will retain something ancestral which will link them to their African brothers. On the other hand, when considering the fate reserved, generally speaking for the Black man in the so-called "civilized" world, we are obliged in the present circumstances, to recognize and with for a certain identify of aim in culture—"Every culture worthy of the name must be able to give and receive" it is said, And the added merit of the Black culture will be that they all have the same legitimate desire to defend the cause of the unjustly used race.

Thus our African brother expresses an implicit faith in the oneness of our spirit that the symbols of our heritage still live within us. Surely it is our task to acknowledge, and seek to renew those ancestral ties. We must begin to see that the African liberation struggle aids our struggle. It is time that we should begin to drink at the fountain of African culture in order to better know our brother. It is my hope that we can establish a cultural link with rising Africa, and that we darker people marching

*Countee Cullen's poem "Heritage" recited.

toward the goal of freedom will trample in the dust the legacy of arrogant superiority, prejudice, and race hate bequested by certain exponents in the Western World. And in our march lift our voices and sing the prophetic hymn by the poet, Margaret Walker:*

Let a new earth rise. Let another world be born.
 Let a bloody peace be written in the sky. Let a
 second generation full of courage issue forth.
 Let a people loving freedom come to growth.
 Let a beauty full of healing and a strength of final
 clenching be the pulsing in our spirits and our
 blood. Let the martial songs be written, let the
 dirges disappear. Let a race of men now rise and
 take control.

*From the poem "For my People."

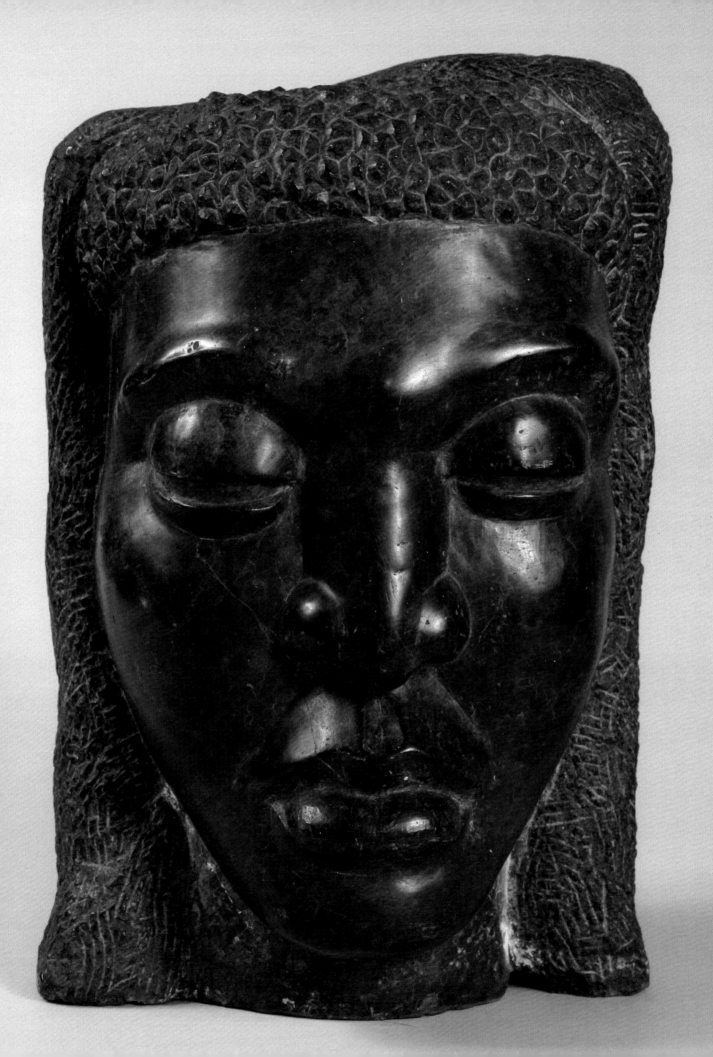

Ethiopia Awakening, 1948

Blessed are the merciful: for they shall obtain mercy. —Matthew 5:7.
This text given by Rev. J. A. Lindsey, St. James A. M. E. Church, Chicago.

LIGHTS AND SHADOWS
"A Little Bit of Everything"

◆ ◆ ◆

Adowa May Be Avenged

O, dark brethren! Awake and mark this
 deed!
This vicious rape by white marauding foe.
Gluttonous dogs! Who seek cruelly to mow
 Our nigh defenseless brothers down! Who
 speed
Superior deadly forces without a heed
 Into heroic ranks! Who spread this woe.
Because they spurned the yoke, nor humbl-
 ed low
 Before an unforgotten pride and greed.
Adowa may be avenged in bloody shame!
 And our kinsmen in glory bravely die,
With swords and spears and ancient mus-
 kets lame;
 Till thousands fallen, stink the peaceful
 sky.
We won't forget, O murderers, your blame!
 Our hate shall spawn in every mother's
 thigh!

—MARION PERKINS

above:
"Adowa May Be Avenged," 1935
poem against Mussolini's invasion of Ethiopia
written by Perkins, published in *The Chicago
Defender*, October 19, 1935

opposite:
Ethiopia Awakening, 1948
Marble
12¼ x 8¼ x 8¼ in.
DuSable Museum of African
American History

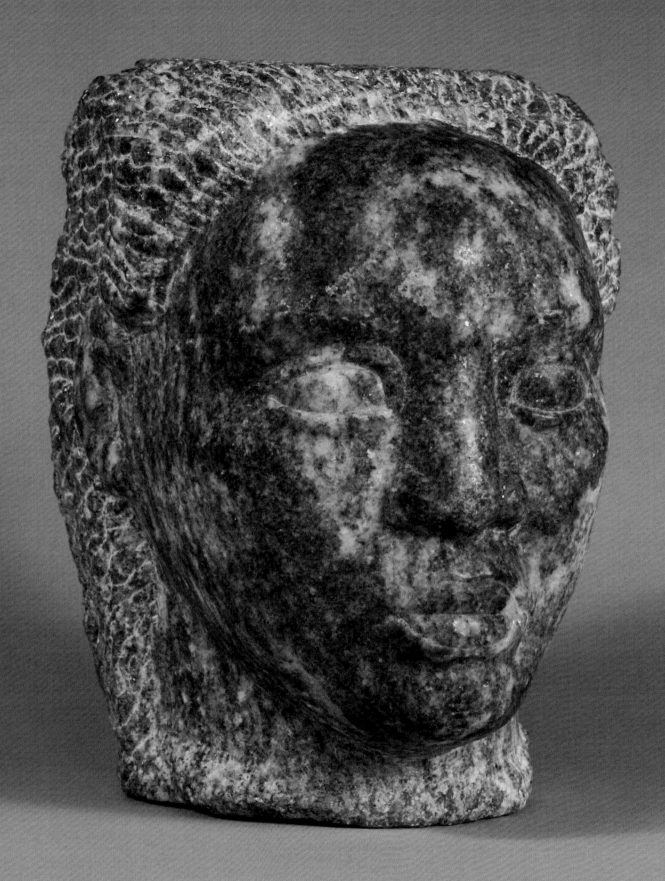

Head of Eva, c. 1947

above:
Eva Gillon Perkins, c.1940s

opposite:
Head of Eva, c.1947
Marble
12¼ x 8½ x 8 in.
The Art Institute of Chicago, through
prior acquisitions of the George F. Harding
Collection

...No Spring for her
Only flesh returned to earth
To nurture flowers, grass and trees.
But your spirit my beloved,
Now mingles among uncountable stars
Of endless Cosmic seas

Excerpt of poem written by Marion Perkins in Eva's memory, 1961

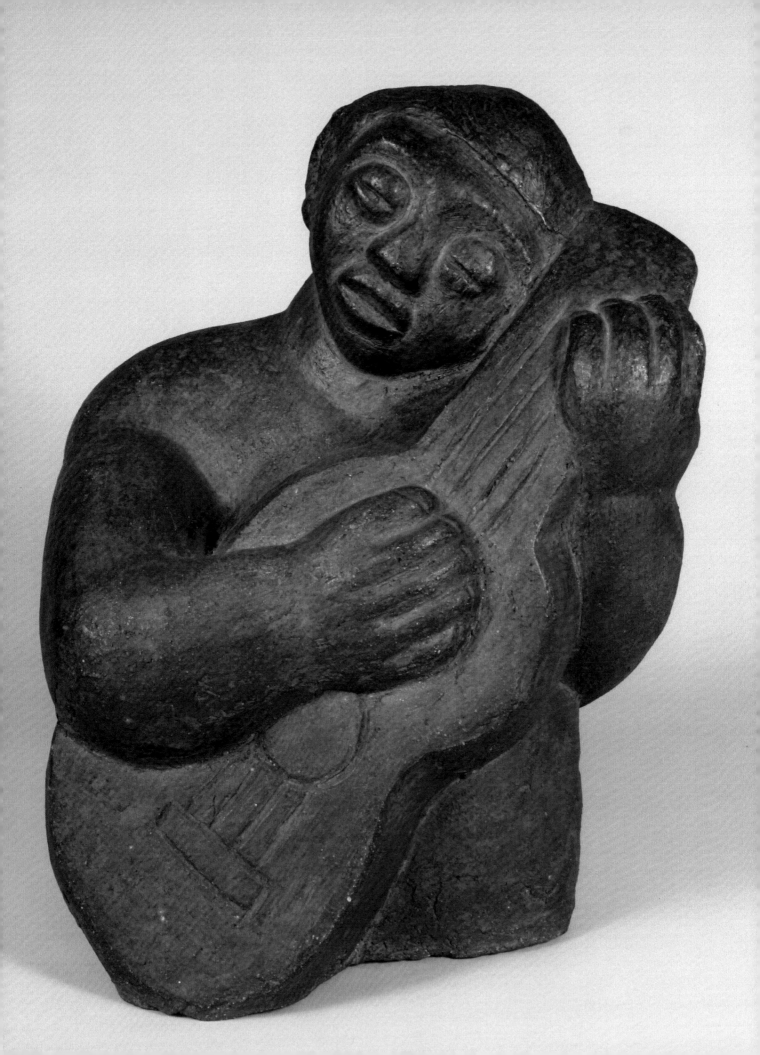

Guitar Player, c. 1945–50

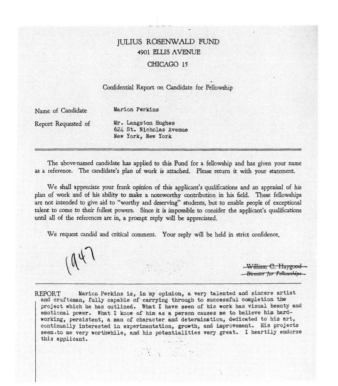

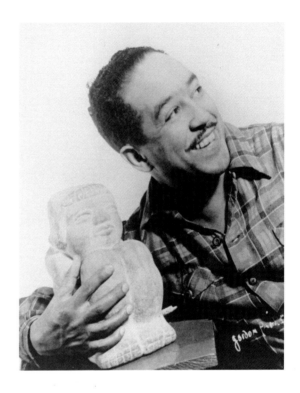

above:
Langston Hughes's confidential report on
Perkins for Rosenwald Fund fellowship, 1947

opposite:
Guitar Player, c. 1945–50
Terra cotta
12 x 10 x 8 in.
Private Collection, Chicago
Courtesy of Lusenhop Fine Art, Chicago

above:
Langston Hughes holding Marion
Perkins's *Sitting Figure*, early 1940s.
Photo by Gordon Parks

. . . What I know of him as a person causes me to believe him hardworking, persistent, a man of character and determination, dedicated to his art, continually interested in experimentation, growth, and improvement . . .

—Langston Hughes, in his recommendation for Marion Perkins

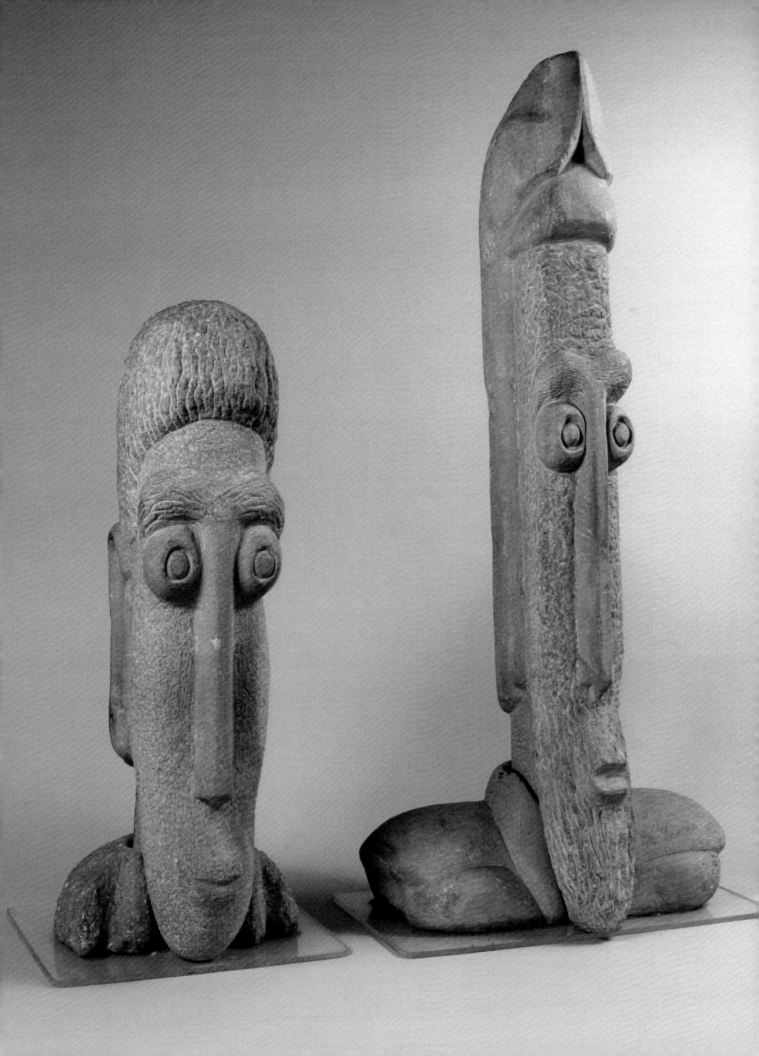

Don Quixote and Sancho Panza, c. 1955

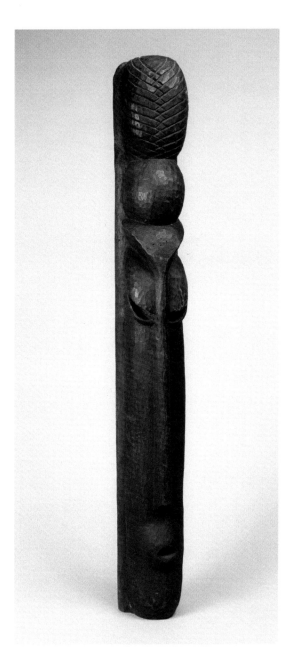

right:
Untitled (African Mask), c. 1955
Wood
36 x 4 x 4 in.
Collection of Thelma and Toussaint Perkins

opposite:
Don Quixote and Sancho Panza, c. 1955
Limestone
23½ x 4½ x 10 and 34 x 16 x 8 in.
Collection of Thelma and Toussaint Perkins

The first time I heard of Marion Perkins was during the Depression when word went around the Southside of Chicago ghetto that a strange fellow was down on 37th and Indiana selling papers and chipping things out of stone.

—Victoria Steele, Masses and Mainstream Magazine, 1952

To An Unknown Political Prisoner, 1953

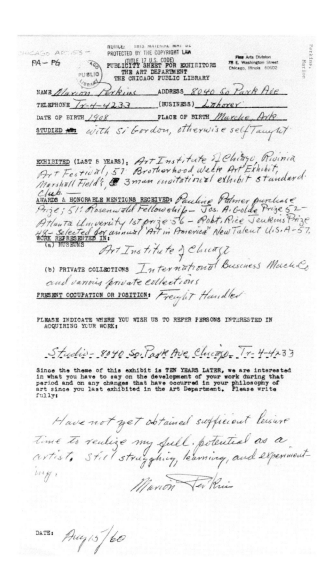

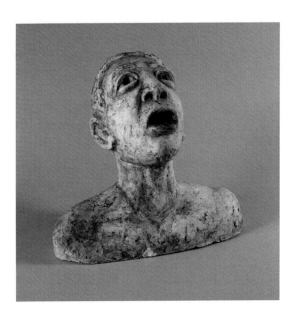

left:
The Chicago Public Library publicity sheet for exhibitors, filled out by Perkins, 1960

opposite:
To An Unknown Political Prisoner, 1953
Limestone
19¾ x 8 x 12 in.
Collection of Quentin Young

above:
Skywatcher, c. 1955
Plaster
16½ x 15½ x 9 in.
Collection of Thelma and Toussaint Perkins

I have not yet obtained sufficient leisure time to realize my full potential as an artist. Still struggling, learning and experimenting.

—*Marion Perkins, quote from questionnaire*

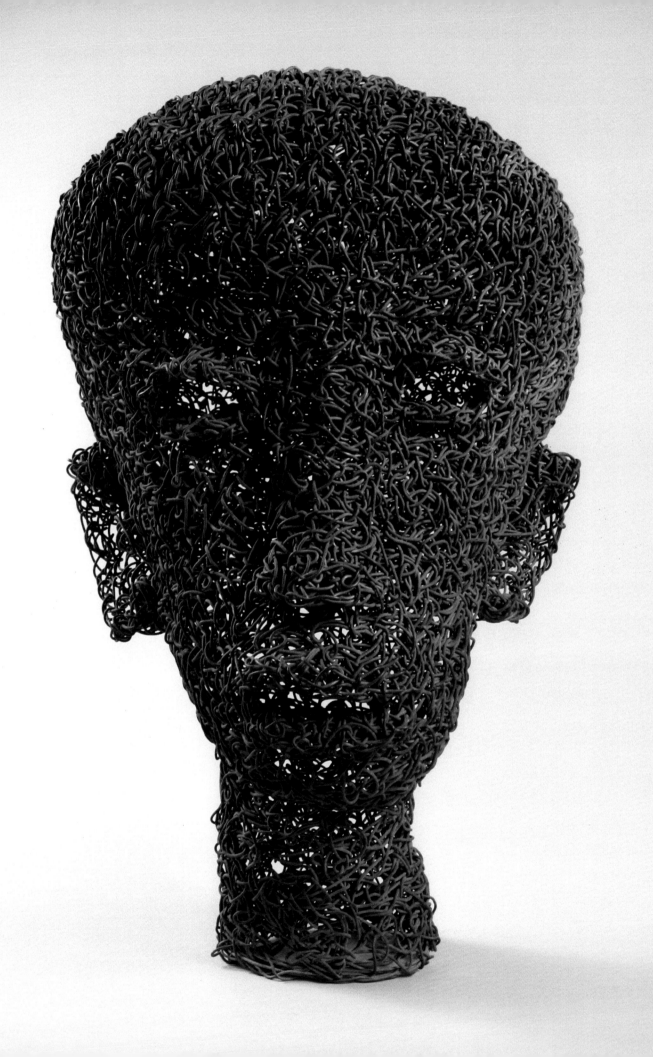

Wire Man, c. 1955

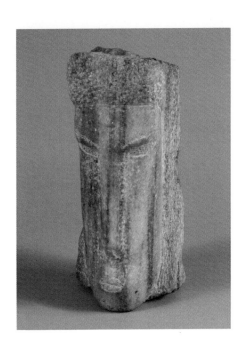

top right:
Untitled (Head), c.1950
Marble
10 x 4½ x 4 in.
Collection of James Parker

bottom right:
Untitled (Rabbi), c.1955
Wood
17½ x 7½ x 7 in.
Private Collection, Chicago

opposite:
Untitled (Wire head), c.1955
Steel wire
19 x 12 x 13 in.
Collection of Thelma and Toussaint Perkins

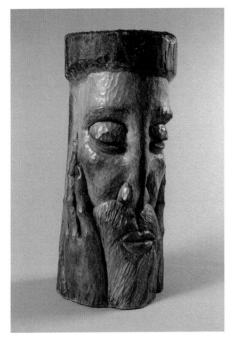

The fact that even some of his early efforts passed competent juries and were included in a couple of important national exhibitions, I believe is fairly conclusive proof that he has something to offer.
—Peter Pollock, South Side Community Art Center

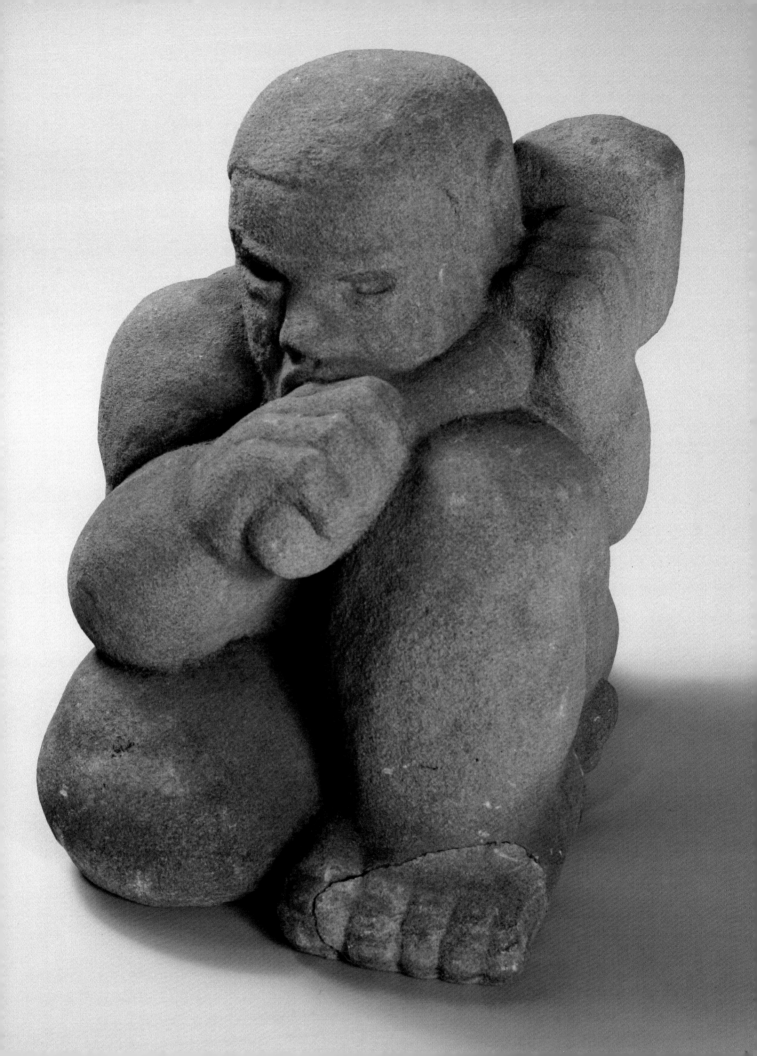

John Henry, 1942

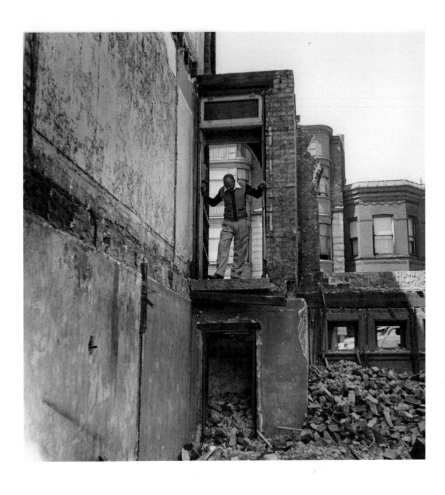

opposite:
John Henry, 1942
Limestone
16½ x 11 x 13 in.
Collection of Thelma and Toussaint Perkins

above:
Marion Perkins searching for sculpture
materials in partially demolished
Bronzeville buildings, 1951.
Photo by Mike Shea.

I am happy to accept this honor, and will be prepared to bring my project on the date specified. The fact that this is the last of the grants being made by the Fund has a tremendous significance to me, and I shall do all that I can to equal the accomplishments of the numerous other Rosenwald fellows who obtained their start from one of the most worthwhile FUNDS in AMERICA.
—Marion Perkins in his acceptance letter to the Rosenwald Fund

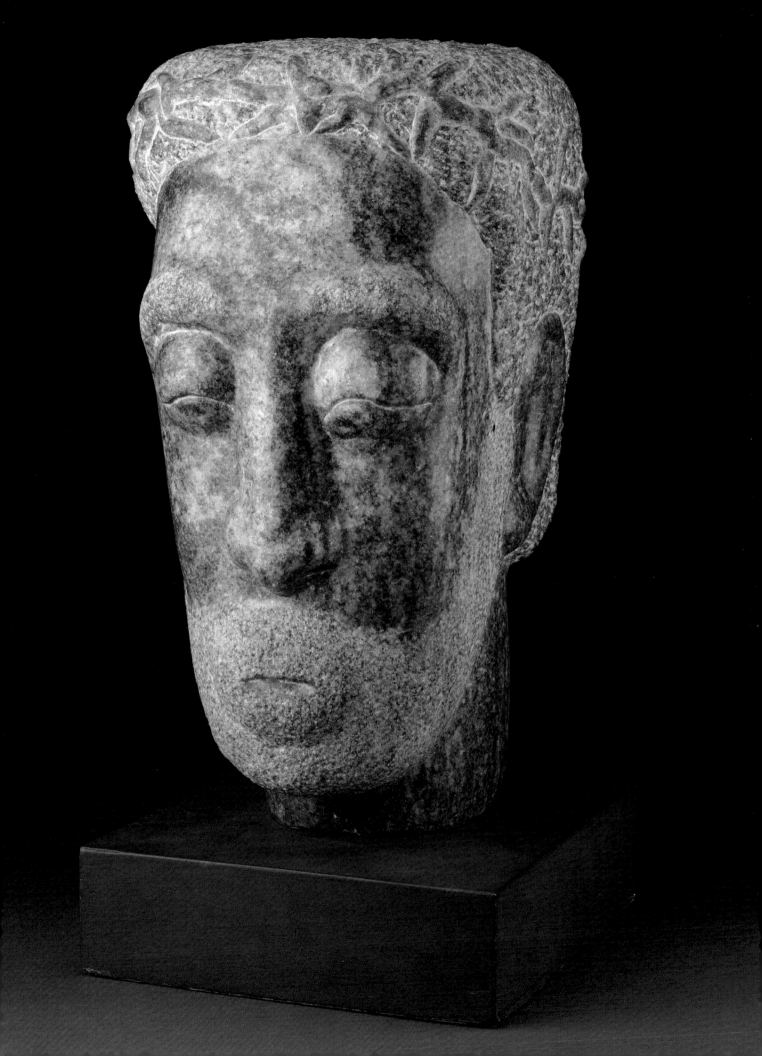

Man of Sorrows, 1950

opposite:
Man of Sorrows, 1950
Marble
17½ x 9 x 9 in.
The Art Institute of Chicago, Pauline Palmer
Purchase Prize

above:
Marion Perkins with *Man of Sorrows*,
Chicago, 1951
Photo by Mike Shea

Afterthought: A Legacy of Creativity and Activism

In 1937, at a rally for the National Relief in Aid of Spanish Refugee Children, Paul Robeson, the consummate artist, humanist and activist stated: "The artist must take sides. He must elect to fight for freedom or slavery. I have made my choice. I had no alternative." I believe this poignant statement also characterizes my father's commitment to his art and to the struggle he fought in behalf of oppressed people.

Like Paul Robeson, Marion Perkins understood that art was not only the expression of an artist's aesthetic vision, but also a manifestation of one's social and political milieu. Moreover, he believed that this confluence of art and self-realization was imperative for Black artists, if they were to define and shape their own artistic paradigm. When my father spoke about Black artists, his sentiments were not confined to sculptors and visual artists. On the contrary, he believed that Black artists of every discipline and genre should treat Black life with honesty and dignity. As one can discern in this catalogue, my father's work conformed to this belief, as shown in his robust interpretation of John Henry and his serene but elegant *Head of Eva*, which honors my mother. This perspective is also clearly articulated in his address to the inaugural National Conference of Negro Artists in Atlanta in 1959.

In this memorable address, he passionately urged fellow Black artists not to look to white critics for approval. Instead, he encourages them to replicate their own empirical experiences and cultural lineage to achieve genuine acknowledgement and parity.

In fact, one may extrapolate from his historic address some of the tenets that were later infused in the Black Arts Movement of the 1960s. His call for greater solidarity among Black artists, for developing racial pride, and for fostering relationships with African artists could all be interpreted as templates of the Black Arts Movement. For example, Amiri Baraka, considered to be one of the premier sages of the Black Arts Movement, denounced "art for art's sake" as bourgeois, saying that it alienated the Black artist from his community. Larry Neal, another leading advocate of the movement argued that "Black art must speak directly to the needs and aspirations of Black Americans." And critic James T. Stewart affirmed that "the Black artist must construct models which correspond to his own reality."

Although my father's political orientation may have differed from the views of artists who embraced the doctrine of Black Nationalism, I believe he would have admired their audacity to challenge the guardians of western art, who claimed they were the optimum voices for establishing the criteria for all art.

Useni Eugene Perkins, son of Marion Perkins

Marion Perkins: Selected Exhibitions

1940
"Exhibition of the Art of the American Negro (1851–1940)." American Negro Exposition, Chicago.

1941
"Exhibition of Negro Artists of Chicago." Howard University Art Gallery, Washington, DC

1942
"Annual Exhibition of American Paintings and Sculpture." Art Institute of Chicago.

1944
"Annual Exhibition of Works by Artists of Chicago and Vicinity." Art Institute of Chicago.

1945
"The Negro Artist Comes of Age: A National Survey of Contemporary American Artists." Albany Institute of Art, Albany, NY.

1947
"Annual Exhibition of Works by Artists of Chicago and Vicinity." Art Institute of Chicago.

1948
"Annual Exhibition of Works by Artists of Chicago and Vicinity." Art Institute of Chicago.

1949
"Annual Exhibition of Works by Artists of Chicago and Vicinity." Art Institute of Chicago.

1951
"Annual Exhibition of Works by Artists of Chicago and Vicinity." Art Institute of Chicago.

"Annual Exhibition of American Paintings and Sculpture." Art Institute of Chicago.

1953
"Contemporary Sculpture by Chicago Artists." Renaissance Society, University of Chicago.

1954
"16 Chicago Sculptors." 1020 Art Center, Chicago.

1956
"Annual Exhibition of American Paintings and Sculpture." Art Institute of Chicago.

1957
People's Art Center, St. Louis, MO.
North Shore Art League, Evanston, IL.

1958
The Standard Club, Chicago.

1959
Contemporary Art Workshop, Chicago.

Old Orchard Art Festival, Skokie, IL.
Riccardo's Restaurant, Chicago.

National Conference of Christians and Jews, Chicago.

North Central College , Naperville, IL.

1960
Chicago Public Library, Chicago.

1961
"New Vistas in American Art." Howard University Art Gallery, Washington, DC.

1976
"Two Centuries of Black American Art." Los Angeles County Museum of Art.

1979
"Marion Perkins." Chicago Public Library.

1982
"Margaret Burroughs, Marion Perkins: A Retrospective." Evans-Tibbs Collection, Washington, DC.

2003
"A Century of Collecting: African American Art in the Art Institute of Chicago." Chicago, IL.

Selected Bibliography

Adams, Russell L. *Great Negroes Past and Present.* Chicago: Afro-Am Publishing Co., 1969.

Albany Institute of History and Art. *The Negro Artist Comes of Age: A National Survey of Contemporary American Artists.* Albany, NY, 1945. Exhibition catalogue.

An Index to Black American Artists. St. Louis: St. Louis Public Library, 1972.

Art Institute of Chicago. "African Americans in Art: Selections from the Art Institute of Chicago." *Museum Studies* 24:2 (1999).

Atlanta University. *Atlanta University Contemporary Art Collection.* Atlanta, 1959. Exhibition catalogue.

Barnwell, Andrea D. *The Walter O. Evans Collection of African American Art.* Seattle: University of Washington Press, 2000.

Bellevue Art Museum. *Hidden Heritage: Afro-American Art, 1800–1950.* Bellevue, WA, 1985. Exhibition catalogue.

Center Gallery, Bucknell University. *Since the Harlem Renaissance: 50 Years of Afro-American Art.* Lewisburg, PA, 1984. Exhibition catalogue.

Chicago Public Library. *WPA and the Black Artist: Chicago and New York.* Chicago, 1978. Exhibition catalogue.

Clapp, Jane, ed. *Sculpture Index.* Metuchen, NJ: Scarecrow Press, 1970.

Dover, Cedric. *American Negro Art.* New York: New York Graphic Society, 1960.

DuSable Museum of African American History. *Two Black Artists of the FDR Era: Marion Perkins, Frederick D. Jones.* Chicago, 1990. Exhibition catalogue.

Evans-Tibbs Collection. *Margaret Burroughs, Marion Perkins: A Retrospective.* Washington, DC, 1982. Exhibition catalogue.

Hampton University. *The International Review of African American Art* 11:4 (1994).

Howard University Gallery of Art. *Exhibition of Negro Artists of Chicago.* Washington, DC, 1941. Exhibition catalogue.

Huntsville Museum of Art. *Black Artists / South.* Huntsville, AL, 1979. Exhibition catalogue.

Illinois Art Gallery, Illinois State Museum. *The Flowering: African-American Artists and Friends in 1940s Chicago: A Look at the South Side Community Art Center.* Chicago, 1993. Exhibition catalogue.

Jones, John. "Negro Artists Win Top U.S. Honors." Life Magazine 23:8 (1946).

Los Angeles County Museum of Art. *Two Centuries of Black American Art.* Los Angeles, 1976. Exhibition catalogue.

Ploski, Harry A., ed. *The Negro Almanac: A Reference Work on the Afro-American.* New York: Wiley-Interscience Publication, 1983.

Riggs, Thomas, ed., *St. James Guide to Black Artists.* Detroit: St. James Press, 1997.

Robert Henry Adams Fine Art. *African American Art in Chicago.* Chicago, 1999. Exhibition catalogue.

Robert Henry Adams Fine Art. *African American Art by Modern Masters.* Chicago, 2004. Exhibition catalogue.

Robert Henry Adams Fine Art. *New Deal to New Power.* Chicago, 2005. Exhibition catalogue.

San Antonio Museum of Art. *The Harmon and Harriet Kelley Collection of African American Art.* San Antonio, 1994. Exhibition catalogue.

Schulman, Daniel. "Marion Perkins: A Chicago Sculptor Rediscovered." Museum Studies 24:2

(Art Institute of Chicago, 1999): 220–243.

Spradling, Mary Mace. *In Black and White: Afro-Americans in Print*. Kalamazoo: Kalamazoo Public Library, 1980.

Taft Museum of Art. *The Great Migration: The Evolution of African American Art, 1790–1945*. Cincinnati, 2000. Exhibition catalogue.

Tanner Art Galleries. *Exhibition of the Art of the American Negro (1851–1940)*. Chicago, 1940. Exhibition catalogue.

1020 Art Center. *16 Chicago Sculptors*. Chicago, 1954. Exhibition catalogue.

Thomison, Dennis. *The Black Artist in America: An Index to Reproductions*. Metuchen, NJ: Scarecrow Press, 1991.

Acknowledgments

This publication has been made possible with major financial support from the following businesses and organizations:

Kraft Foods

The Joyce Foundation

The Vivian G. Harsh Society

The Chicago Public Library

Third World Press Foundation

Special thanks to the following businesses and individuals whose generous financial contributions helped make this catalogue possible:

M. M. Azzi Fine Art & Design, Inc.

Valerie Gerrard Browne

Denise Gardner

Eleanor Hambric

Charles and Kathleen Harper

Lusenhop Fine Art

Patrick McCoy

Isobel Neal

James T. Parker

Dale Taylor

Donna Allie and David L. Rivers

Pirficro Williams *Deceased

Susan Cayton Woodson

The following individuals and institutions made invaluable contributions to the exhibition and publication:

Archives of American Art, Smithsonian Institution

The Art Institute of Chicago

Judith A. Barter , Field-McCormick Curator and Chair of American Art, the Art Institute of Chicago

Alan Dobry and Lois Friedberg Dobry

DuSable Museum of African American History

A special thank you to members of the Marion Perkins Exhibition Committee for their months of hard work and support that resulted in the exhibition, associated programming, and this publication:

Beverly Cook

Michael Flug

David Lusenhop

Robert Miller

Julia E. Perkins

Marian Perkins Phillips

Toussaint and Thelma Perkins

Useni Eugene Perkins

Daniel Schulman

Elise Ward

Antoinette Wright

Dr. Quentin Young